Z2-PR
X

SEEING THINGS SIMPLY
FIGURES

LESSONS & EXERCISES TO DEVELOP
YOUR PAINTING & DRAWING TECHNIQUE

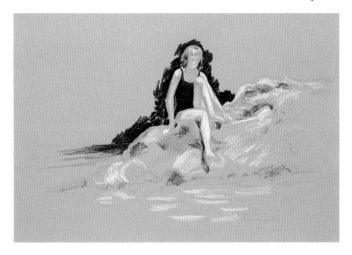

DAVID CUTHBERT

**CHARTWELL
BOOKS, INC.**

A QUINTET BOOK

Published by Chartwell Books
A Division of Book Sales, Inc.
110 Enterprise Avenue
Secaucus, New Jersey 07094

This edition produced for sale
in the U.S.A., its territories
and dependencies only.

ISBN 0-7858-0065-4

This book was designed and produced by
Quintet Publishing Limited
6 Blundell Street
London N7 9BH

Creative Director: Richard Dewing
Designer: Ian Hunt
Project Editor: Helen Denholm
Editor: Hazel Harrison
Photographer: Paul Forrester

Typeset in Great Britain by
Central Southern Typesetters, Eastbourne
Manufactured in Hong Kong by
Regent Publishing Services Limited
Printed in China

CONTENTS

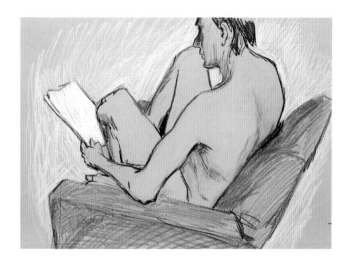

INTRODUCTION

DRAWING AND PAINTING the human figure – whether nude or clothed – presents the ultimate challenge to an artist. This is partly because the forms are in themselves complex and varied, and partly because figure drawing requires a higher degree of accuracy than most subjects. If you are painting a still life, it may not affect the painting very much if a plate is not quite circular, or if the two sides of a bottle are not equal. However, in a life drawing, if one arm is shorter than the other, or if you misunderstand the proportions and make the head too small or the legs too short, it will be very noticeable. We all know what our fellow humans look like, and can immediately identify unlikely proportions.

Once you have mastered some basic rules about proportion and structure, it is largely a matter of practice. I did no figure drawing when I was at art school; life drawing was not fashionable then, and although there were models around, few students made use of them.

Later on, however, I had to teach myself – fast – because I got a job teaching a life class. I have never been sorry, as I enjoy this branch of painting enormously, and still work from a model whenever possible.

Many of my drawings are in crayon or pastel, but when I paint I always use acrylic, which I like because any mistakes can quickly be rectified by overpainting, and also because it is a versatile medium that can be used thick or thin, on paper or on canvas. I recommend that those painting the figure for the first time try acrylic rather than a hard-to-handle medium such as watercolor, which can lead to early discouragement. Above all, draw whenever you can, as this is the best way to learn. You do not have to join a life class; you can draw yourself in the mirror and make sketches of friends and family, or people you see on buses and trains – we are all surrounded by "unofficial" models.

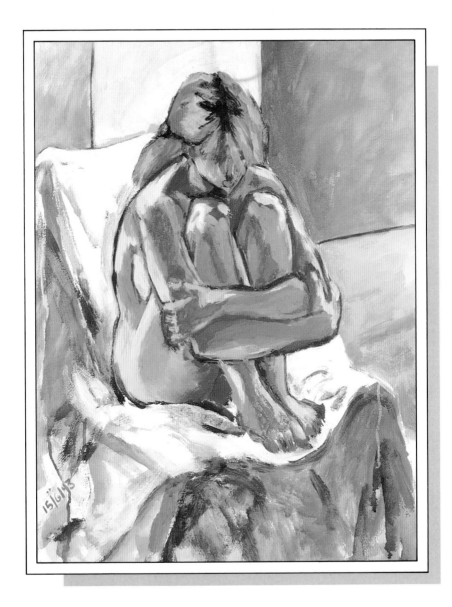

HUMAN PROPORTIONS

ALTHOUGH FIGURES VARY almost more than you could imagine, there are some general facts about proportions that are useful to bear in mind. The accepted rule is that the body is approximately seven and a half heads high, so artists use the head as a convenient unit of measurement. However, do not follow this rule too rigidly, as you will seldom find a person who conforms to the "ideal." Also, fashions change – women with very small heads were once *de rigueur*, as you can see from the drawings opposite. These have been taken from studies by Renaissance artists who followed the Classical "ideal" of proportions.

When you are drawing full-length standing figures, it is helpful to know that the midpoint is not the waist, as is commonly imagined, but just above the crotch, while the one-quarter point is above the breast and the other below the knees.

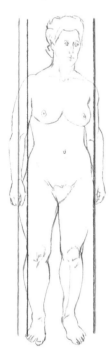

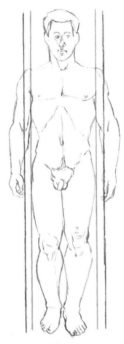

LEFT
The man's shoulders are broader than the woman's, and the hips are narrower.

OPPOSITE
The Classical ideal gave women smaller heads and more elongated torsos.

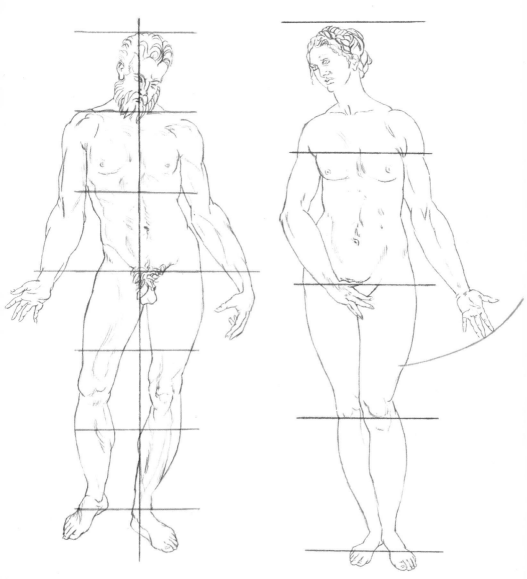

REAL PEOPLE

THE BEST WAY to learn to draw figures is by doing it. You do not necessarily have to attend a life class to observe individual differences; quick sketches of the kind shown here will teach you more than pages of theory. Draw people – sitting, standing, in movement, in repose – as often as you can, looking for their characteristic postures and the way they hold their heads and move their limbs.

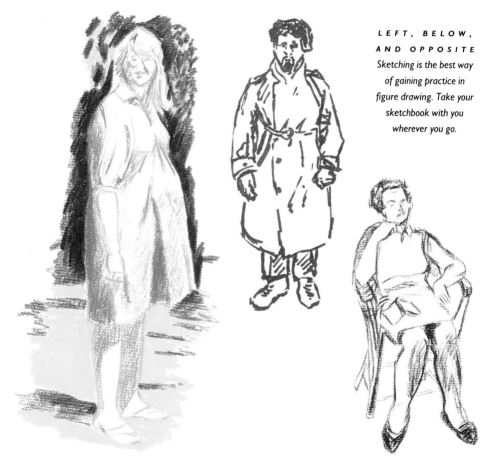

LEFT, BELOW, AND OPPOSITE
Sketching is the best way of gaining practice in figure drawing. Take your sketchbook with you wherever you go.

THE BODY'S FRAMEWORK

ANATOMY WAS ONCE TAUGHT as a matter of course in art schools. Nowadays it is considered of less importance, but if you want to make convincing drawings and paintings of the figure, it is helpful to have a working knowledge of the skeleton, since many of the bones are at least partially visible under their covering of muscle and flesh.

Of particular importance are the clavicle (collarbone); the scapula (shoulderblade) in a back view; the pelvis and ribcage; the top of the thighbone, which meets the collarbone to form the shoulder; and the shinbone.

It is also worthwhile looking closely

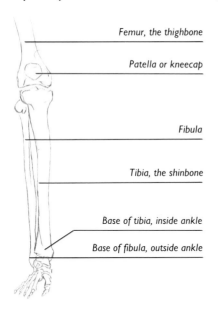

Femur, the thighbone

Patella or kneecap

Fibula

Tibia, the shinbone

Base of tibia, inside ankle

Base of fibula, outside ankle

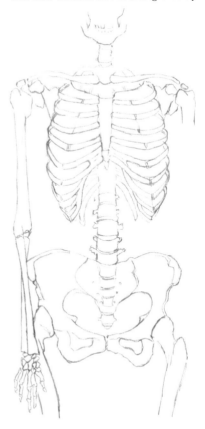

ABOVE
The bones that make up the lower leg and the knee and ankle joints.

RIGHT
The female skeleton. Here you can see clearly the difference in size between the male and female pelvis.

at the knee and ankle bones, as these joints are notoriously hard to get right. As you can see in the drawing of the lower leg, the knee consists of four separate bones: the kneecap itself – a relatively flat, irregular circle, narrower at the bottom – and the heads of the thighbone, shinbone and fibula.

The ankle is a swing joint formed by the lower ends of the two leg bones meeting the bones (tarsals) of the foot. Notice that the base of the fibula is lower than the base of the tibia, giving the characteristic front profile of the ankle. This is often misunderstood by beginners.

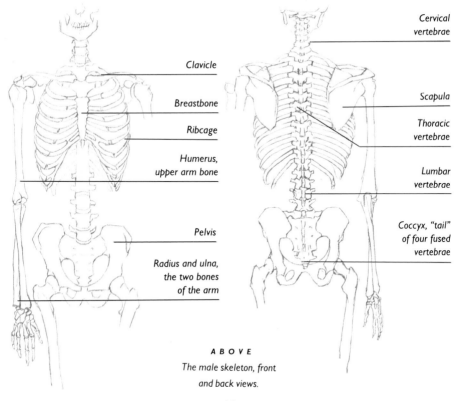

Clavicle

Breastbone

Ribcage

Humerus, upper arm bone

Pelvis

Radius and ulna, the two bones of the arm

Cervical vertebrae

Scapula

Thoracic vertebrae

Lumbar vertebrae

Coccyx, "tail" of four fused vertebrae

ABOVE
The male skeleton, front and back views.

THE SKELETON IN ACTION

THE AMOUNT OF THE SKELETON you can see in an actual person depends both on the pose and on the physique of the model. In a normal physique, for example, you will see the ribcage and collarbone, and possibly the top bone of the pelvis, while the bony structures of the knee, ankle, and shin are always visible because they are covered only by a layer of skin.

In a back view you will see the shoulderblades, while the spine will appear as a slight depression caused by the sheet of muscles that wrap around the torso and tuck into the spine (see pages 14–15).

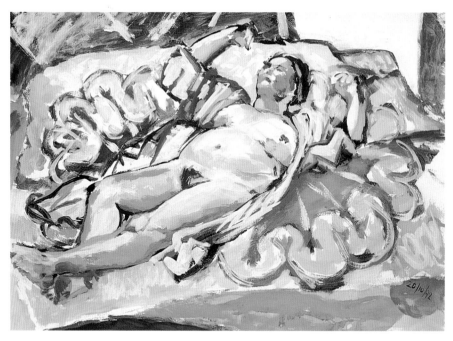

ABOVE
Here the covering of flesh and fat almost entirely
hides the skeleton, although the knee and ankle
bones can still be seen.

RIGHT

In a thin model such as this one, the underlying skeletal structure is very obvious. Both paintings were done in acrylic, a medium well suited to life studies because you can overpaint as much as you like to correct any mistakes.

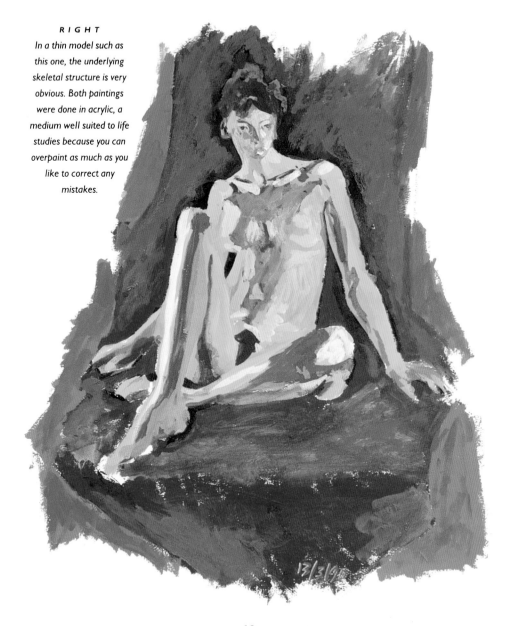

MUSCLES

THE NETWORK of interconnected muscles that make the body move is so intricate that it could take many months to memorize all the names – which fortunately is not necessary. There are 200 muscles on each side of our body, some of which are needed simply to keep us standing still.

What is most important in drawing and painting is to recognize the difference between tensed and relaxed muscles because this changes the shape of the limbs. The most obvious example is the biceps, which, when flexed, bunches up to produce a pronounced bulge in the upper arm. The same applies to the calf muscles, which in repose are not obvious. However, if you watch a person walk across the room or climb up stairs you will see the way these muscles flex and relax.

L E F T
It is worth looking at drawings like these in books of anatomy to give you an idea of the way the muscles work.

O P P O S I T E
In this acrylic painting you can see how the large sheet of muscle, which wraps around the side of the trunk and which is connected to the lower vertebrae, forms a distinct depression. You can also see the shoulderblades very clearly, as they are pulled forward by the model's pose.

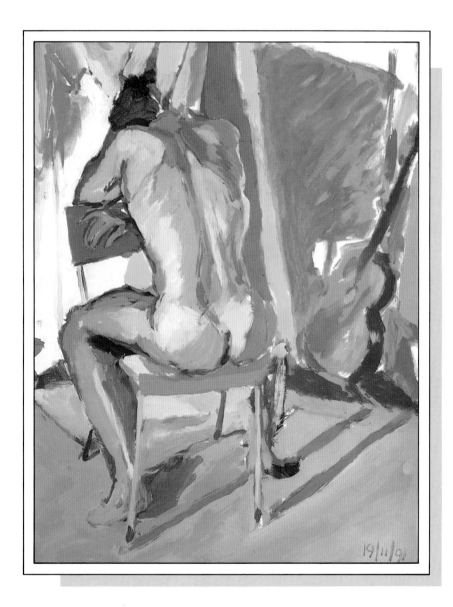

19/11/91

BE YOUR OWN MODEL

ONE OF THE BIGGEST difficulties with learning to draw the figure is getting hold of models. Friends and family may agree to pose now and then, but you may find that they lose patience just when you are beginning to enjoy yourself! However, you always have one model you can rely on – yourself – so practice drawing or painting self-portraits. Try posing yourself in different clothes so that you can see how clothing affects the underlying forms (see pages 44–5), or in the nude if you are sufficiently unselfconscious.

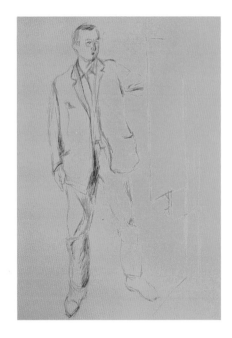

A B O V E
Note the careful
treatment of the hand in
this pencil drawing.

A B O V E R I G H T
Pencil drawing on
colored paper.

O P P O S I T E
In this chalk drawing the
colored paper has
helped to build up both
dark and light tones.

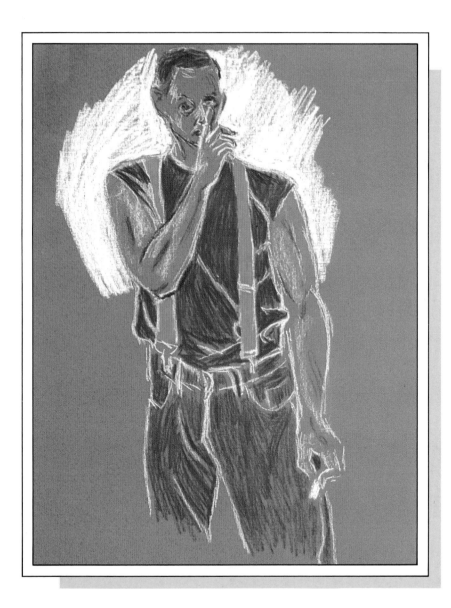

THE CENTER OF BALANCE

WHEN YOU ARE DRAWING or painting a standing figure it is vital to get the balance right, or the figure will not look convincing. You can use either a plumbline or a pencil held up vertically at arm's length to check the "balance line." The "balance point" is the middle of the neck for a front or back view, and the middle of the ear for a side view. Hold the plumbline up to the relevant point, and see where this line intersects the ground.

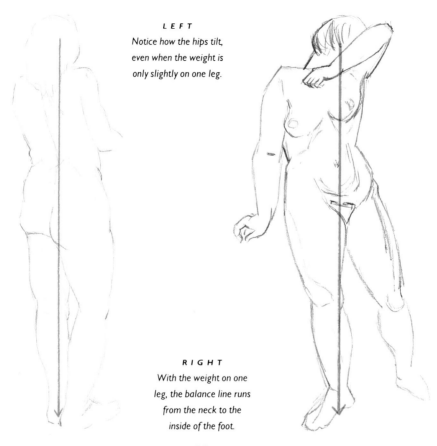

LEFT
Notice how the hips tilt, even when the weight is only slightly on one leg.

RIGHT
With the weight on one leg, the balance line runs from the neck to the inside of the foot.

You will see that the relationship of the balance line to the feet alters as soon as the model moves. Ask your model to stand first with legs slightly apart and the weight evenly divided between both legs, and then to change position and stand with most of the weight resting on one leg. In the former case the line will intersect the ground in the middle of the feet, while in the latter it will touch the ankle of the weight-bearing leg.

You can also use a plumbline to mark other useful reference points in a drawing, such as the line from shoulder to leg. The more checks of this kind you can make, the more accurate your drawings will be.

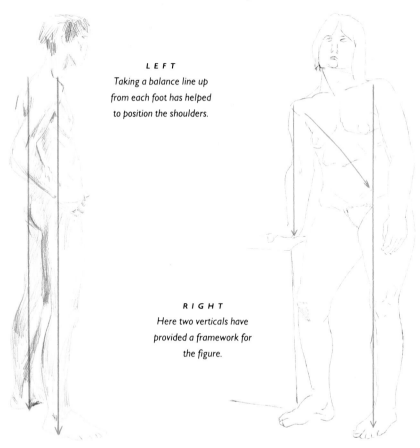

LEFT
Taking a balance line up from each foot has helped to position the shoulders.

RIGHT
Here two verticals have provided a framework for the figure.

THE SEATED FIGURE

WHEN A PERSON is sitting down the balance is more subtle and difficult to assess than when standing, as the weight is resting on the chair, and the model may or may not be leaning back against it. The plumbline system (see pages 18–19), however, is equally useful for seated figures as for standing ones, and here it has been used to mark a central line from the base of the neck. In a seated or reclining pose it is important to give an impression of the weight and solidity of the body and the way it is supported by the chair or sofa, and you can only do this if you get the angle of the body and limbs right. It is often helpful to make a series of diagonal lines through certain key points.

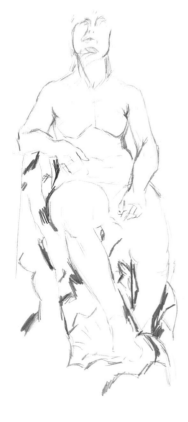

L E F T
You can establish the proportions of the body and "dynamics" of the pose by systems such as that shown opposite.

O P P O S I T E
The red lines. *The central line gives a reference for checking the angle of the body and position of the foot. The horizontal lines help me to check the proportions of body to leg. There is more about measuring proportions on pages 24–5.*

The blue lines. *Notice that because the model is leaning back, the middle of the belly is not on the central line but to the right of it. I have therefore drawn a diagonal from here to the neck and down to the inside of the thigh. Other diagonals help me to establish the angle of the legs and arms and their relationship to each other.*

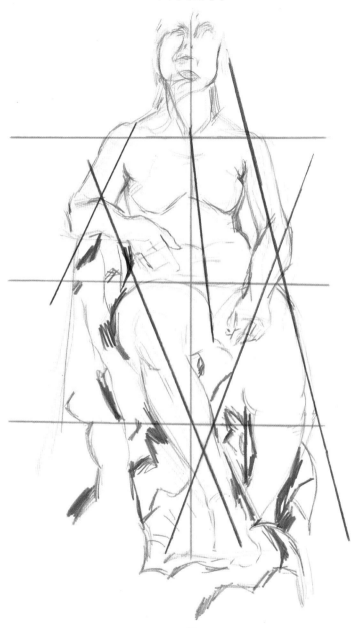

QUICK POSES

IF YOU HAVE ATTENDED a life class you may be familiar with the sinking feeling induced by the words "and now we are going to do three-minute poses." It does sound daunting, but in fact short poses are essential to the student – and to the professional – and they are also genuinely liberating. They are essential because they force you to look for what is really important about a pose, and

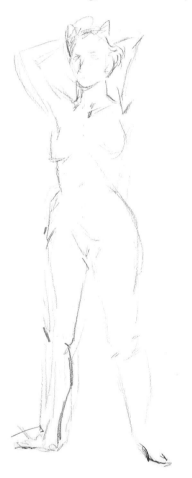

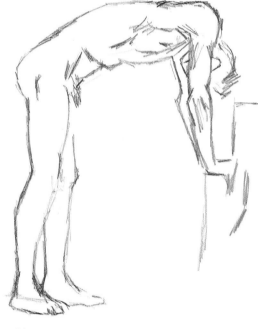

LEFT
This chalk drawing was done in only three minutes.

BELOW
Chunky graphite stick was used for this five-minute pose.

they are liberating because you simply have no time to worry about whether your drawing is either right or wrong, good or bad.

If you do not have access to a model you can try drawing people engaged in outdoor pursuits, or even simply walking across a room. You will find that it is not so very difficult, and if you have to tear up one or two sheets of paper it does not matter – you will still be gaining valuable practice. It is best to start with a medium that you can use broadly, such as charcoal, rather than pencil, which tends to invite a more hesitant approach.

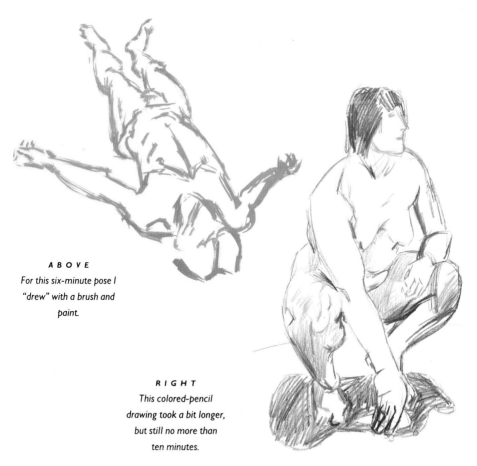

ABOVE
For this six-minute pose I "drew" with a brush and paint.

RIGHT
This colored-pencil drawing took a bit longer, but still no more than ten minutes.

MEASURING

MOST ARTISTS, both past and present, have employed some system of measuring when drawing the figure. It is all too easy to misunderstand a proportion, making feet and hands too small – a common error – or legs too long. This is particularly true when the figure is foreshortened (see following pages), causing unexpected distortions. Here, for instance, the thighs are foreshortened because they are going away from the viewer and therefore appear shorter than they are in reality.

The head is usually used as the unit of measurement. Hold up your pencil at arm's length, and measure the head by sliding your thumb down the pencil. Then, keeping your fingers and thumb in place, move the pencil down, mark another line, and so on right down the body. You can continue to use measuring systems as the drawing progresses. For example, if something looks too small or large, measure it against the head again, and if it is wrong make adjustments. You can also check other key sizes, establishing, for instance, whether a leg is twice the width of an arm or less.

RIGHT
*Take careful measurements of your
model using the pencil and fingers
method shown opposite.*

24

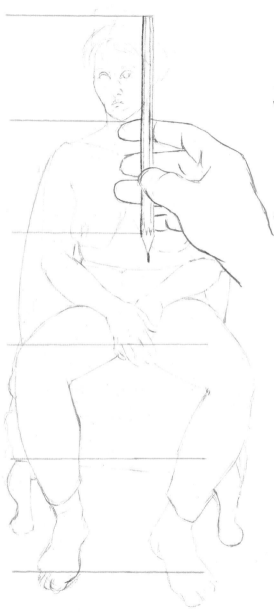

LEFT
The pencil must always be exactly the same distance away from you or all the measurements will change. This is why it is important to hold it at arm's length — your outstretched arm is always the same length, but if you bend your arm you will be unable to resume exactly the same position.

FORESHORTENING

FORESHORTENING IS what happens when one part of a form is nearer to you than another. Perspective makes things appear to shrink as they recede from you, so that if you look at a reclining model from the feet end you will see that the head looks very small and the feet very large.

All inexperienced artists – and a good many professionals – have problems with foreshortening. The trouble is that the effects it causes are often so extreme that you simply cannot believe your own eyes. You know that a head is a certain size, so how can it now be so small in relation to the body? But you have to learn to trust your eyes; the rules of proportion are no good to you when it comes to foreshortened forms. It is essential to take careful measurements using the pencil and fingers method shown on the previous pages.

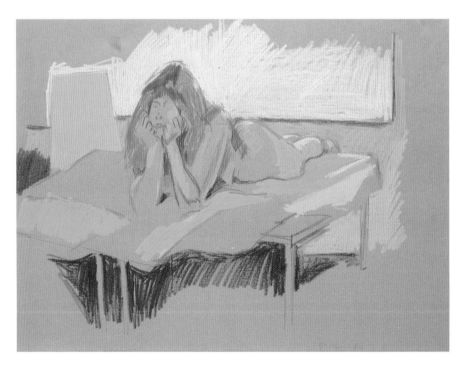

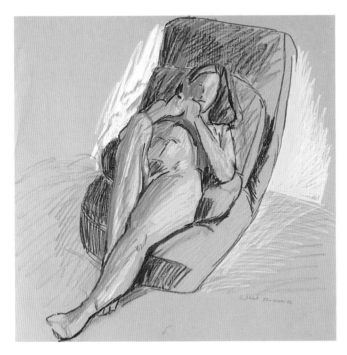

LEFT
Notice how large the legs
are in relation to the head
in this pastel drawing.

BELOW
Here the forearm and
legs are foreshortened.
The drawing is in chalk.

OPPOSITE
In this pastel study, the
head and arms are the
nearest points, so the
buttocks and legs
progressively shrink.

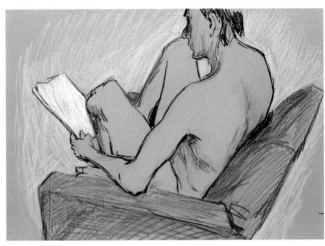

TONAL MODELING

IT MAY SEEM OBVIOUS to say that the body is a three-dimensional form, but it is surprising how many beginners fail to draw it in this way, producing a series of hard outlines that make the figure look like a flat cut-out. To correct this linear tendency, teachers sometimes ask students to produce drawings in which no lines are used at all – working with the side of a charcoal stick or a short length of pastel, the figure is built up entirely by means of tone.

The word tone is sometimes misunderstood, but its meaning is quite straightforward – tone is the lightness or darkness of a color. When you are modeling form in a monochrome medium like charcoal or pencil this means you must pay careful attention, not to the colors you can see, but to where the shadows and highlights fall, as it is these that describe the forms. Because the body is made up of so many individual shapes – the soft curve of a breast, for example, flowing into the flatter plane of the top of the chest and the angularity of the collarbone – this tonal modeling can be difficult to master, but it is central to drawing and painting the figure.

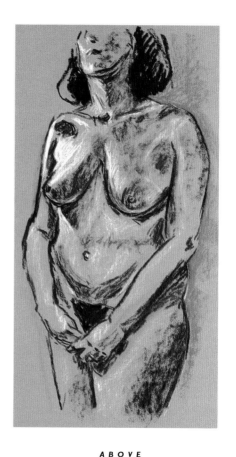

A B O V E
Working on colored paper with black and white chalk, as in this drawing, gives you a head start, as the paper can be used as the mid-tone.

28

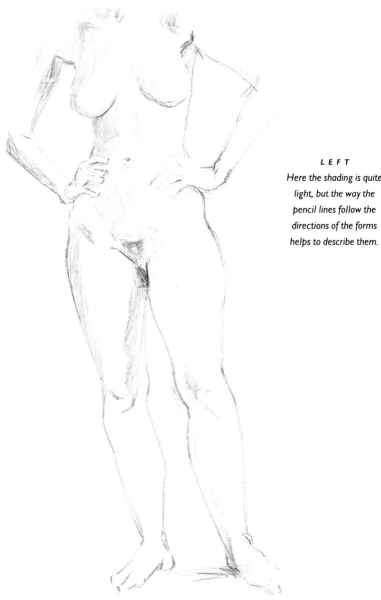

LEFT

*Here the shading is quite
light, but the way the
pencil lines follow the
directions of the forms
helps to describe them.*

MODELING WITH COLOR

AT THIS POINT it is worth mentioning that painting the figure is no more difficult than drawing it. Some people even find it easier, as you have the extra dimension of color on your side. You do, of course, still have to assess the lightness or darkness of the colors you are using so that you can create effects of light and shade, but you do not have to translate them into shades of gray.

Color "temperature" is an important factor in modeling form. Artists divide colors into "warm" and "cool," the former being the reds, yellows and oranges, and the latter the blues, blue-grays, and blue-greens. Shadows are usually cool in color, while the lightstruck areas are warm. You can see this effect in the painting below. Bear this in mind, because using juxtapositions of warm and cool allows you to create a colorful painting without sacrificing the three-dimensionality.

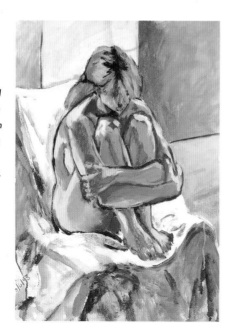

RIGHT

In this acrylic painting I have used strong but cool blues on the fronts of the arms and legs, with warm yellows and pinks for the lightstruck areas at the top and sides of the body.

OPPOSITE

Here the colors are less vivid, but you can see cool grays on the arms, legs, neck, and shoulders, while the highlights contain subtle blends of color. This is also in acrylic, which I find the ideal medium for figure work.

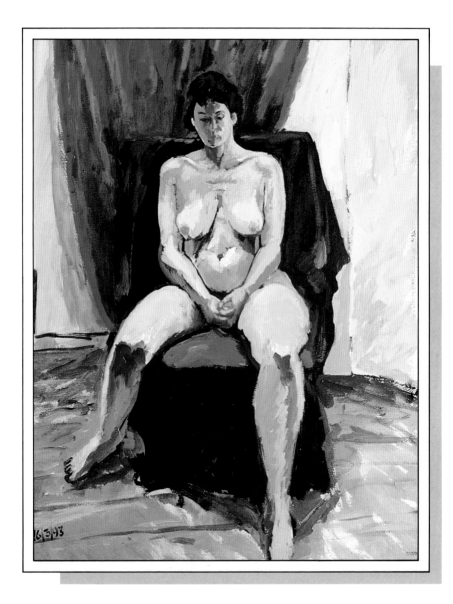

FORM AND LINE

HAVING JUST BEEN WARNED off putting outlines around forms, you may find it contradictory now to be told that you can make a perfectly convincing drawing with line alone. You can, but it all depends on the way you use line. A hard, uniform outline will certainly flatten forms, but if you vary the line, using solid ones where the edge of a form is clearly defined, and lighter ones – or no line at all – where you see little or no contrast of tone, you can suggest form quite precisely. Remember, too, that line is not necessarily the same as outline. There are lines within the body, particularly the torso, that follow the contours of forms, and if you draw these correctly they will describe the form.

L E F T
Notice the contour lines within the body in this colored-pencil drawing, particularly those around the belly. These show the swelling roundness with no need for tonal modeling.

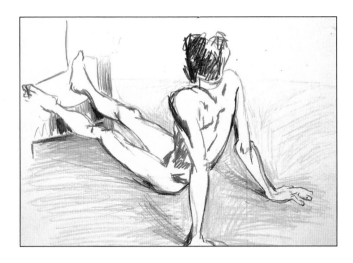

LEFT
Here I have again drawn
in colored pencil. The
lines are varied from bold
and thick – notably
around the shoulder and
below the left leg – to
light and delicate.

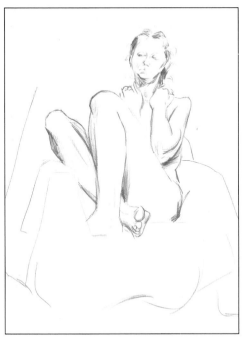

LEFT
This red chalk drawing
combines line with a
touch of tonal modeling,
but the shading lines have
been kept loose in
keeping with the overall
linearity.

NEGATIVE SPACE

WHEN YOU DRAW or paint a figure it is natural to fix your attention on what you are drawing rather than to look at what is behind and around it. But what is known as "negative space" or "negative shapes" is an important concept in art. The spaces between objects are not only important in composition; they also provide a very useful way of checking what may have gone wrong with your drawing.

Suppose you are drawing a standing figure with arms resting on hips. You can see that the arms are somehow not right, but you are not sure why. Try looking at the spaces between the body and the hips, and see whether these shapes are the same in your drawing. If they are not, you have probably misunderstood the angle of the arms or made the hips too wide or too narrow. It is an interesting exercise to make a whole drawing of the spaces rather than the body, as shown here. You may find it difficult at first, but you will be surprised how much your drawing improves once you become aware of these shapes.

RIGHT
I have drawn on black paper with white chalk here, filling in the negative shapes before touching in a few lines to give the figure solidity.

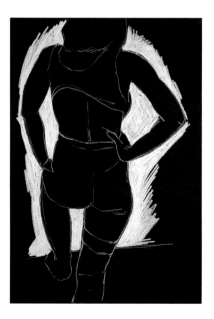

OPPOSITE
In this semi-abstract treatment in pastel the negative shapes are as important as the positive ones, playing a major role in the composition.

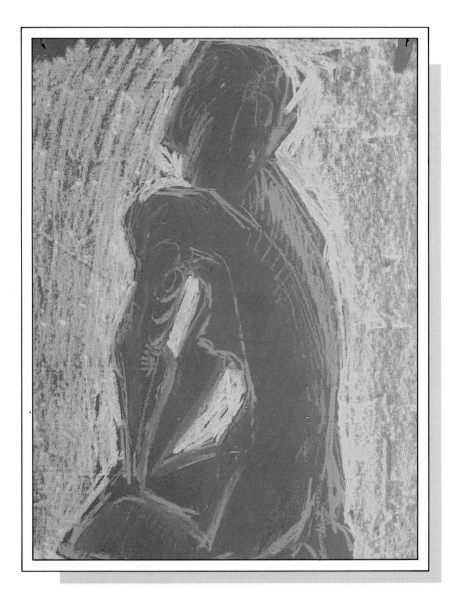

COMPOSITION

WHEN YOU ARE JUST DRAWING to gain practice you do not have to worry about "composing" your drawing, but when you start to paint the figure or to make finished drawings you must consider this aspect of art. Composing simply means fitting your subject into the rectangle of the paper so that it looks pleasing and well balanced, and avoiding any awkward cropping. Cropping can, in fact, be very effective, but it must be well planned. For example, if you chop off the feet it looks as though you just could not fit them in,

ABOVE
This sort of mistake can easily happen. Avoid it by measuring key points first (see pages 24–5), and marking them off on your paper.

RIGHT
The figure is placed off-center, with the diagonal line made by the right leg leading the eye up to the arms and face.

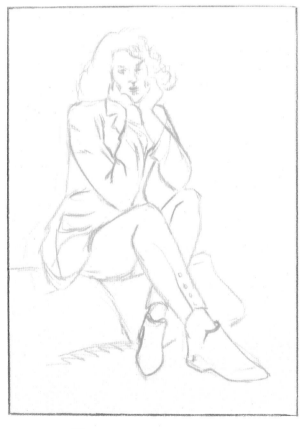

but you can deliberately restrict yourself to half or three-quarters of the figure, from the head to below the waist, or from the head to the knees.

One of the basic rules of composition is asymmetry: in general, the center of interest – the figure – should not be placed directly in the middle of the picture unless there is something in the background or foreground to break the symmetry. Nor should it be seen in isolation; you must give as much thought to the background and any other elements, such as the chair for a seated figure, as you do to the figure itself. Artists often make small thumbnail sketches before starting a painting, working out the most interesting arrangements, and I suggest that you do the same.

A B O V E
It is usually a mistake to begin with the head and work down-wards since you will often find you have no room for the feet.

R I G H T
This figure has been set in the context of a room, but there are too many other distracting objects in both foreground and background so the overall effect is muddled.

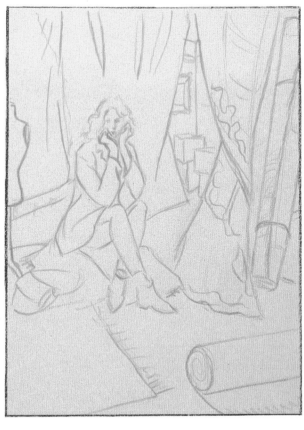

THE HEAD AND NECK

BEGINNERS OFTEN make the mistake of drawing the head as a rough oval shape and then trying to join it onto the neck and shoulders, but this is seldom successful. The head and neck should be treated as a single unit, as the angle of the head is important in suggesting the flow of movement from one to the other. Every movement of the head affects the muscles and tendons that join the two together, the most important of these being the large muscles that run from behind the ear to the collarbone, meeting to make a V-shape at the base of the neck. This muscle can be seen clearly in the drawing on the opposite page, below left.

RIGHT

Seen in semi-profile, with the model looking slightly upwards, the neck makes a graceful, sweeping line, echoed by the fall of hair. This was drawn with a graphite stick.

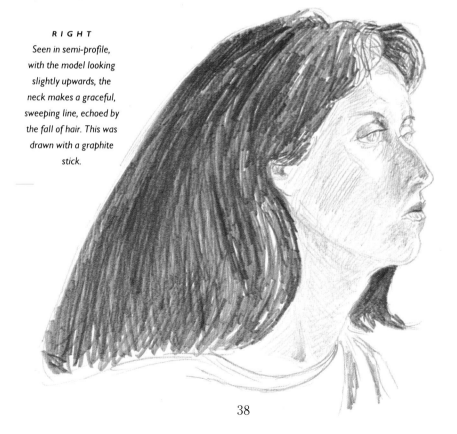

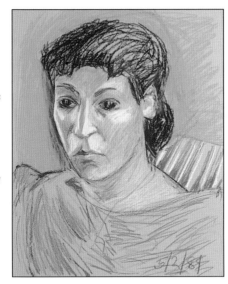

RIGHT
Necks vary enormously.
Here the round softness is
suggested by directional
pastel strokes.

BELOW
In this pencil drawing you
can see the clear line of
the muscle from ear to
collarbone.

BELOW
Men's necks are in
general more sinewy than
women's, and are
distinguished by the
Adam's apple. Pencil
drawing.

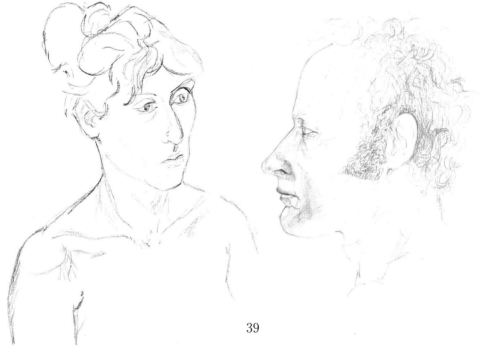

THE HAND AND WRIST

MANY OTHERWISE GOOD FIGURE DRAWINGS and paintings are spoiled by poor observation of hands. A particularly common error is to make them much too small. Hands are actually surprisingly large. If you look in a mirror and cover your face with your hand, you will see that from wrist to fingertips it is almost as long as your face.

The best way to learn to draw hands and wrists is to draw your own, first stretched out flat so that you learn the proportions. You will see that the fingers are approximately half the length of the whole hand. Then draw your hand in different positions, perhaps curled around an object such as a mug. Notice how the flat plane of the wrist widens

out where the two wrist bones join the bones of the hand, and then narrows and tapers at the fingers. You may find it useful to copy other artists' work, as below, or to draw hands from photographs in magazines and newspapers.

When you come to draw or paint the model, you will find that you can often simplify the shapes of the hand. Try to follow the movement of the arm into the hand, and start by drawing the hand as two flat planes, one made by the top of the hand and the other by the fingers. Once you have got the proportions and direction right you can begin to make refinements, but if you begin by drawing individual fingers you will lose sight of the wood for the trees.

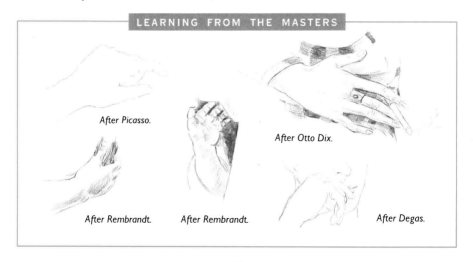

LEARNING FROM THE MASTERS

After Picasso.

After Otto Dix.

After Rembrandt. After Rembrandt. After Degas.

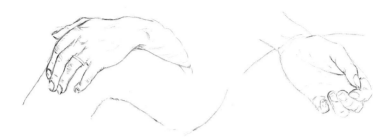

ABOVE

When the hand rests on or curls around a form, it follows the contours of that form. You can see this in the drawing on the left. Notice, too, how the ring helps to define the shape of the finger.

LEFT

When the hand rests on a surface it is bent up at an angle from the wrist, making a pronounced crease.

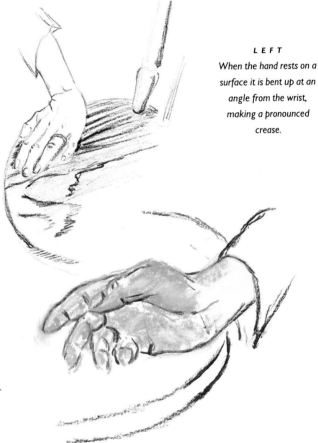

RIGHT

The hand in this position is tricky to draw, as you cannot simplify it into basic shapes. You will have to rely on observation and practice.

41

THE FOOT AND ANKLE

FEET ARE ANOTHER PROBLEM AREA in figure drawings, but again it is usually the proportion that is misunderstood. Feet, like hands, are often drawn too small, but when you think about it you realize they must be relatively large, since they have to carry the weight of the whole body – the foot is approximately one head in length.

The foot is basically a wedge shape, with the highest part running in line with the big toe. This basic shape should always be established before you begin to draw in the toes. Practice drawing your own feet and ankles in a mirror, from different angles and both standing and sitting. Remember that your best model is always yourself, though you may also find it valuable to copy other artists' drawings and paintings. Something you will notice is that the two projections made by the ankle bones are not level with each other, the one on the inside being higher. This is an important fact, often overlooked when drawing from life.

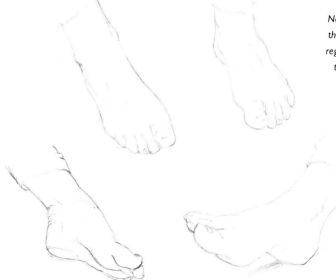

LEFT AND BELOW

Notice how the toes in these drawings form a regular curve, although the big toe projects slightly upwards.

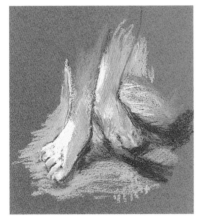

After Degas.

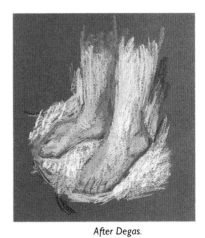

After Degas.

After Dali.

CLOTHING DEFINES FORM

DRAWING THE NUDE is generally regarded as the ultimate test of the artist, and with good reason. The complex interplay of forms can be very bewildering. The clothed figure, of course, presents its own problems, but it does offer you some clues to help you define form. The line of a collar, for instance, will often help to describe a neck; a watch strap going around a wrist will provide a contour line for you to follow; tight clothing will sometimes form descriptive creases, and so on. It is very much like looking for the visible bone under the flesh when you are drawing the nude figure (see pages 12–13). Unless the clothing is extremely loose or made of thick fabric (see following pages), parts of the body will be visible while others remain hidden.

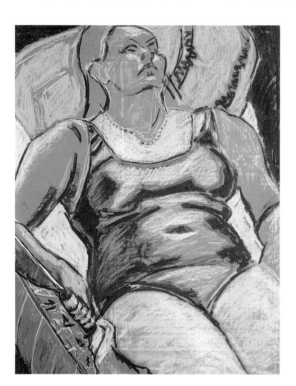

L E F T
The model's swimsuit in this pastel study defines the forms very helpfully. Notice particularly the way in which the shoulder straps narrow as they curve away around the shoulders.

O P P O S I T E
The shapes of the thighs are clearly discernible; the black T-shirt follows the curve at the base of the neck, and the right-hand shirt sleeve curves over the bent arm. The drawing is in colored crayon.

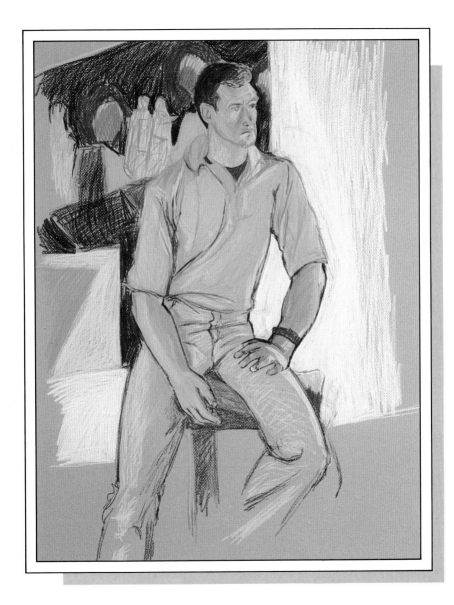

CLOTHING AS A DISGUISE

CLOTHING DOES NOT always help to define forms; sometimes it actually disguises them. A thick overcoat, for example, will give you very little idea of the body beneath it, and loose clothing will hide much of it, although you may have occasional clues, such as fabric hanging in folds from a knee or creasing over a thigh. You have to try to imagine the body beneath the clothes, and observe your sitter carefully. You can often construct the pose from the parts of the body you can see – for instance, the angle of the legs appearing from beneath a skirt will tell you a lot about how the head and neck are positioned.

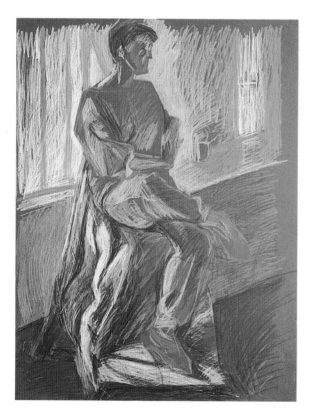

LEFT
Although the clothing is loose, it is also light and hangs from certain parts of the body. The knees, thighs, and shoulders are clearly distinguishable. The drawing is in colored pencil.

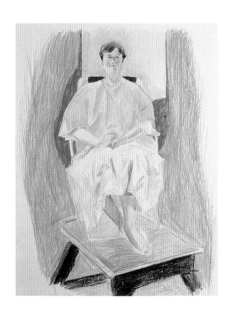

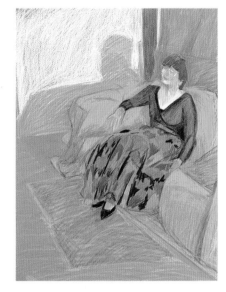

ABOVE

In this drawing, also in
colored pencil, the skirt
drapes over the tops of
the thighs, and the blouse
fails to disguise the
shoulders completely.

ABOVE

Here the tight top defines
the forms, while the
voluminous skirt hides
them. The folds of the
skirt, however, follow the
angle of the legs.

UNUSUAL LIGHTING

LIGHTING IS VITAL in figure work, particularly when you are painting the nude, as it helps you to model form convincingly and give a solid, three-dimensional impression. But there is more to lighting than that; it can also create mood and drama. Rembrandt, for instance, used strong contrasts of light and shade (known as *chiaroscuro*) to focus attention on a face or figure, and some artists like to paint people in artificial light, which casts a yellowish glow.

It is worth experimenting with unusual lights, perhaps trying the effects of colored light bulbs or a thin, colored blind over a window. If you attend a life class, rather than working on your own, you might ask the teacher to consider some experiments of this nature. You can also, of course, exaggerate the colors to emphasize lighting effects, as I have done in the painting below in which I have exaggerated the color of the evening light.

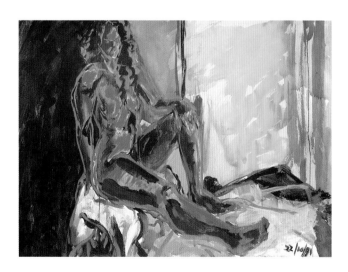

OPPOSITE
The fire casts a warm glow on the model's back, which I have emphasized by working on a blue-gray paper and restricting the color to this part of the painting.

ABOVE
In this acrylic painting I have exaggerated the natural color bias of an evening light.

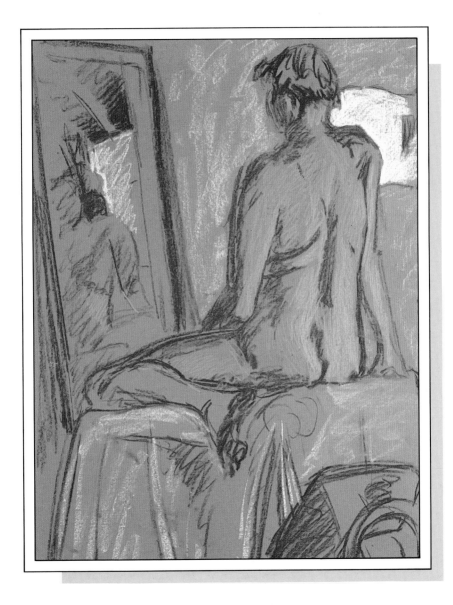

CONTRE JOUR

THIS FRENCH PHRASE means "against the light," and the effects it creates are perenially popular with both artists and photographers – the latter call it backlighting. When the light comes from behind the figure, it makes a silhouette or halo effect, with most of the body in shadow. This can transform a relatively ordinary composition into something unusual, since it can create very unexpected shapes and colors. The effects vary according to how bright the light is, how far the model is from it, and the pose itself – the figure may be completely against the light or at a slight angle to it.

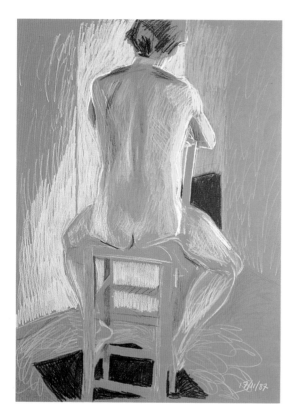

LEFT
For this colored-crayon study I posed the model at a slight angle to the light source so that the strongest illumination is on the right. The dark red-brown paper provided a "color key" for the shadows on the figure's back.

OPPOSITE
Here the contre jour effect is stronger, with the shadowed part of the body making a definite shape. The painting is in acrylic, applied very thinly to give a watercolor effect.

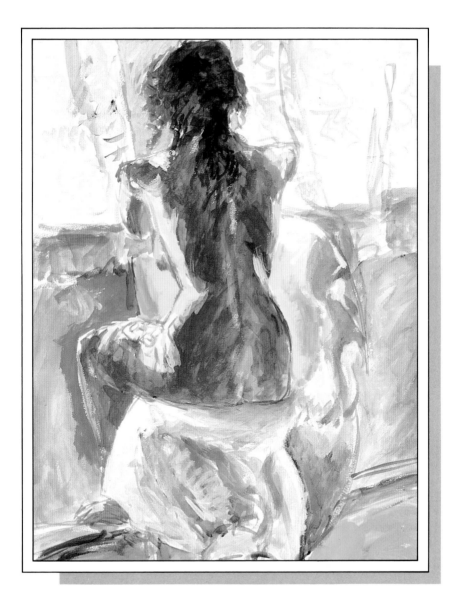

USING COLOR CREATIVELY

WHEN YOU FIRST START to paint you will be concerned with practical problems of color. How, for instance, do you mix a particular shade of pinkish-yellow for skin? How can you make a shadow dark enough without deadening it? But there may come a time when you want to do something more than just reproducing

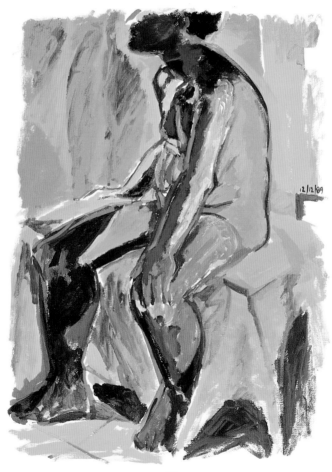

what you see as faithfully as possible, and when you feel you could use color more creatively.

It is a curious thing that people will often use non-naturalistic color in a landscape or still life but feel nervous about doing so in a figure painting. Perhaps we have too much respect for the model, or identify too closely with another member of the human race. But there is no reason why you have to paint everything just as it is – art is about translating the real world. So if you want to exaggerate colors or even invent them, go ahead and enjoy yourself.

OPPOSITE
If you see an overall color bias in a subject, you can heighten all the colors to emphasize it, as in this case. Although the colors are not strictly "true to life," they still convey the impression of the human body.

RIGHT
Even though I have departed radically from the normal flesh colors, this painting is still recognizable as a human subject.

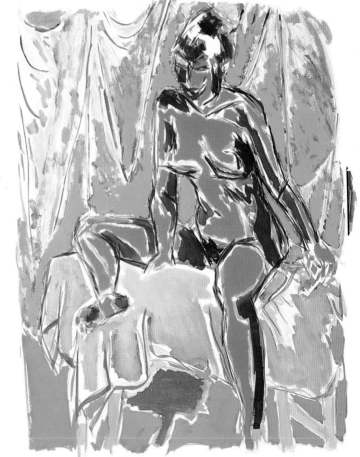

THE FIGURE IN CONTEXT

ONCE YOU HAVE BECOME confident in your ability to draw and paint people, you can include them in landscapes and urban scenes, which can often benefit from a touch of human interest. The best way to go about this is to make sketches, which you can then call upon when you are planning a painting. Few, if any, artists can invent figures, and so they build up a store of visual references in this way. Sketching is, in any case, excellent practice. It is one thing to draw the figure in the artificial context of a studio when you have plenty of time to analyze the pose and to correct mistakes, and quite another to draw people in movement and going about their business.

When you make sketches that you may use for paintings, it is important to give an impression of the setting, or there is a risk that you may place the figures out of scale in your painting. If you are drawing people in a street, sketch in the buildings behind them to give an indication of relative sizes.

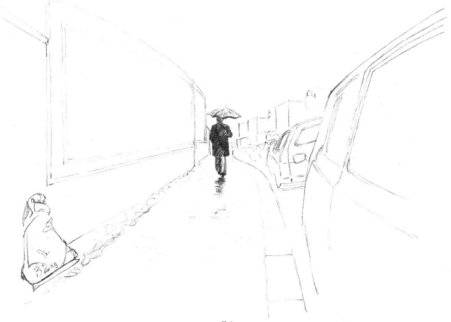

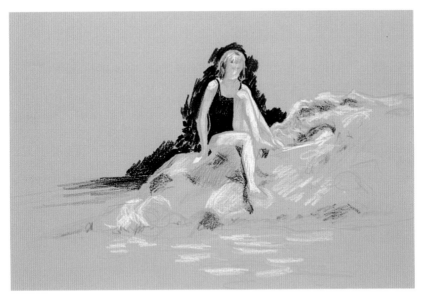

A B O V E
In this pastel drawing I have paid equal attention to the figure and to the rock on which she is sitting, as this affects the pose.

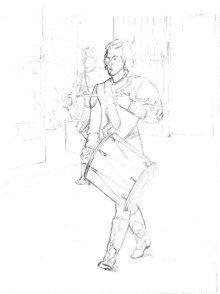

O P P O S I T E
When drawing figures in an urban setting, it can be easier to sketch in the setting first, as this ensures that the figures are in the correct scale.

L E F T
An indication of the buildings in the background provides a context for the figure.

55

FIGURES IN INTERIORS

WHEN YOU DRAW AND PAINT the life model in a studio, you are, of course, dealing with a figure in a setting, but you may not necessarily include the setting in your work – life studios are not generally very stimulating in visual terms. You will not be very much concerned with the particular character and atmosphere of your model, either.

A life class is basically an artificial set-up; sitting on a chair with no clothes on is not something most people do as part of their normal lives. Painting a person in their natural environment is a very different matter and is akin to portraiture. Here you want to give an impression of the person's character and interests, and to convey a sense of them belonging to their surroundings. Try making drawings of members of your family engaged in some characteristic activity – cooking, reading, gardening, watching television, and so on.

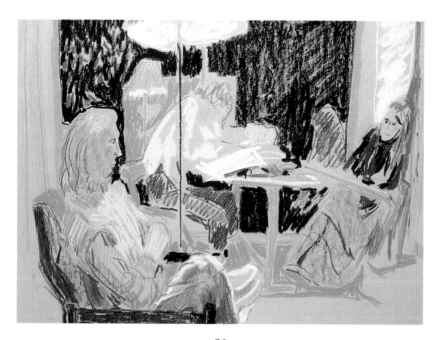

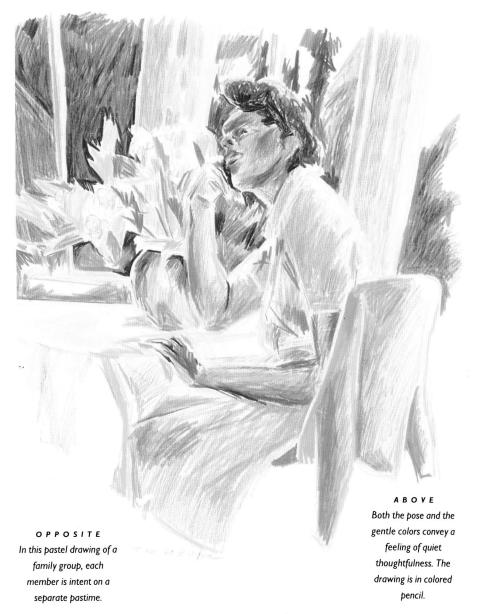

OPPOSITE

In this pastel drawing of a family group, each member is intent on a separate pastime.

ABOVE

Both the pose and the gentle colors convey a feeling of quiet thoughtfulness. The drawing is in colored pencil.

DEMONSTRATION

WHEN I PAINT the nude I nearly always use acrylic, as I have here and in most of the paintings shown throughout the book. I like it because it allows me to overpaint when necessary – even professional artists sometimes have to correct mistakes and redefine forms. Acrylic can also be used as both an opaque and a transparent medium, which allows you to change a color by overlaying a thin, transparent layer of paint. You will notice that I have done so in this painting. Acrylic can be used either on paper or on canvas, but I prefer paper and work on a thick watercolor paper with a medium surface which is lightly textured. I use long-handled bristle brushes since I like to stand well back from my work. The colors used here are cadmium yellow, cadmium orange, transparent gold ocher, bright green, Rowney emerald, Hooker's green, Monestial blue, permanent violet, Venetian red, and middle gray.

1 The model in position.

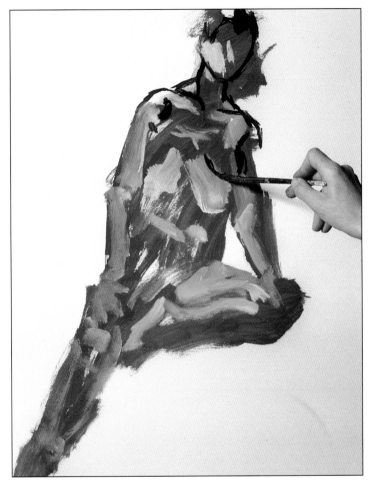

2 What I found exciting about this pose was the strong diagonal emphasis, so I began by establishing the main shape, sweeping from one corner of the paper to the other. The color is Venetian red, which forms a good base for warm flesh tones.

3 Because I start with the color straight away, rather than making an underdrawing in line, I may have to make corrections. I now see that I have to lift the top of the figure, so I use a thin brush to redraw the key points.

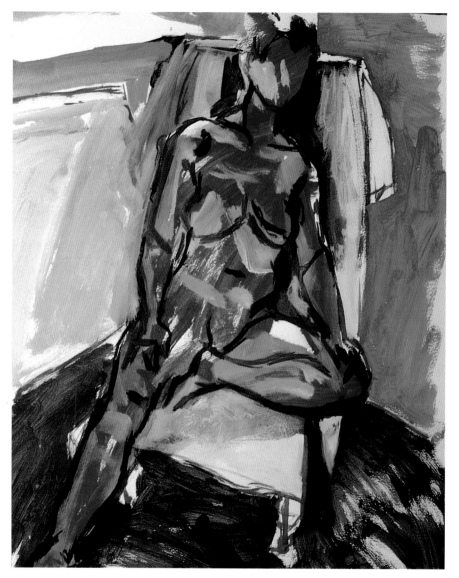

4 With the redrawing complete, I can begin to consider color and have blocked in areas of bright and dark green and deep blue.

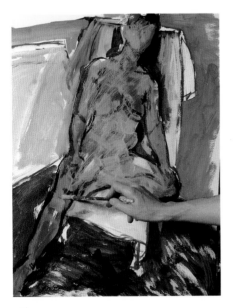

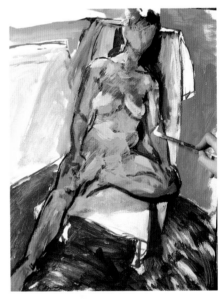

5 To establish the warm golden color of the skin, I now cover the Venetian red that I used earlier with a glaze of transparent gold ocher. Notice how the underdrawing and underpainting still show through.

6 I now work into this base color, using opaque paint to build up the highlights that define the forms.

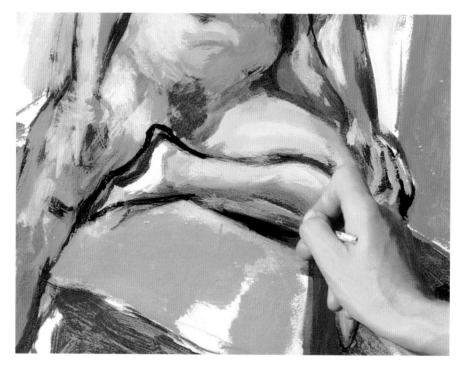

7 The area where the foot overlaps the right leg is tricky, and I have had to do some further redrawing.

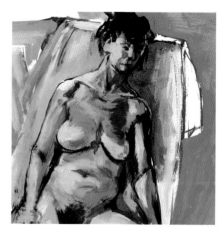

8 In this detail you can see the wide variety of colors I have used, including a patch of relatively vivid magenta on the belly. The golden-orange base color has been left uncovered in places, unifying the other colors.

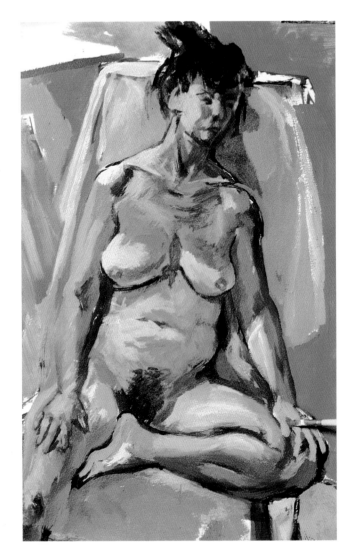

9 Details such as hands and face are best left until last. Here I work on the left hand, putting on brushstrokes of pale paint where the fingers and the side of the thumb catch the light.

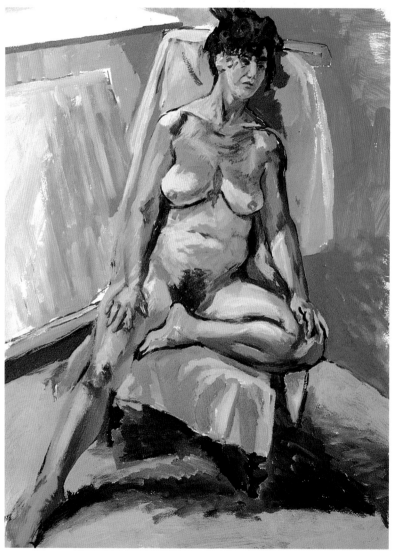

10 Final touches were to tidy up the background and foreground, and to paint over the patches of white paper still left uncovered.